MVB PRINTMAKER COLORING BOOK VOL. 1

30 ORIGINAL DRAWINGS
BY
MICHAEL VINCENT BUSHY

2016

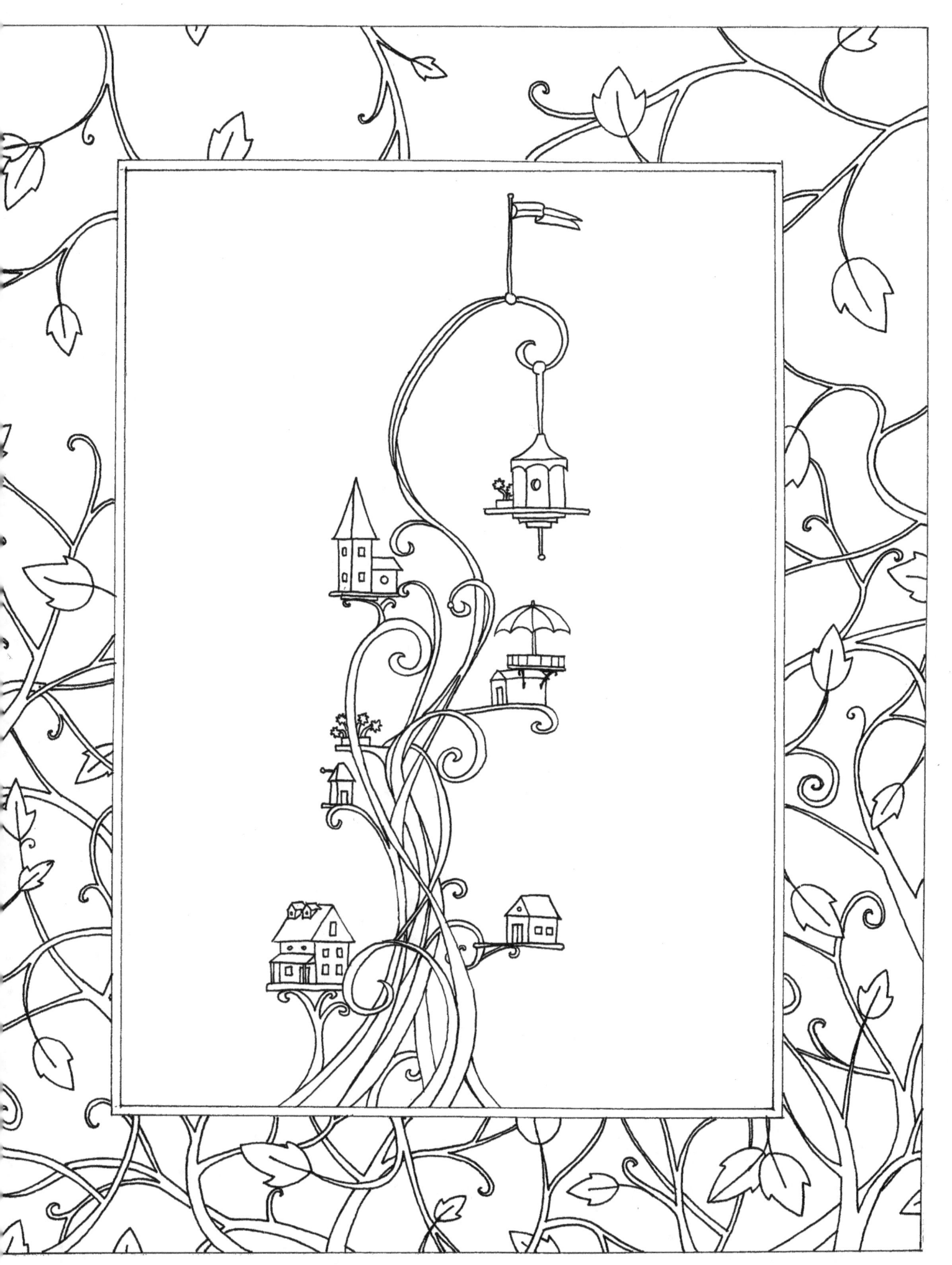

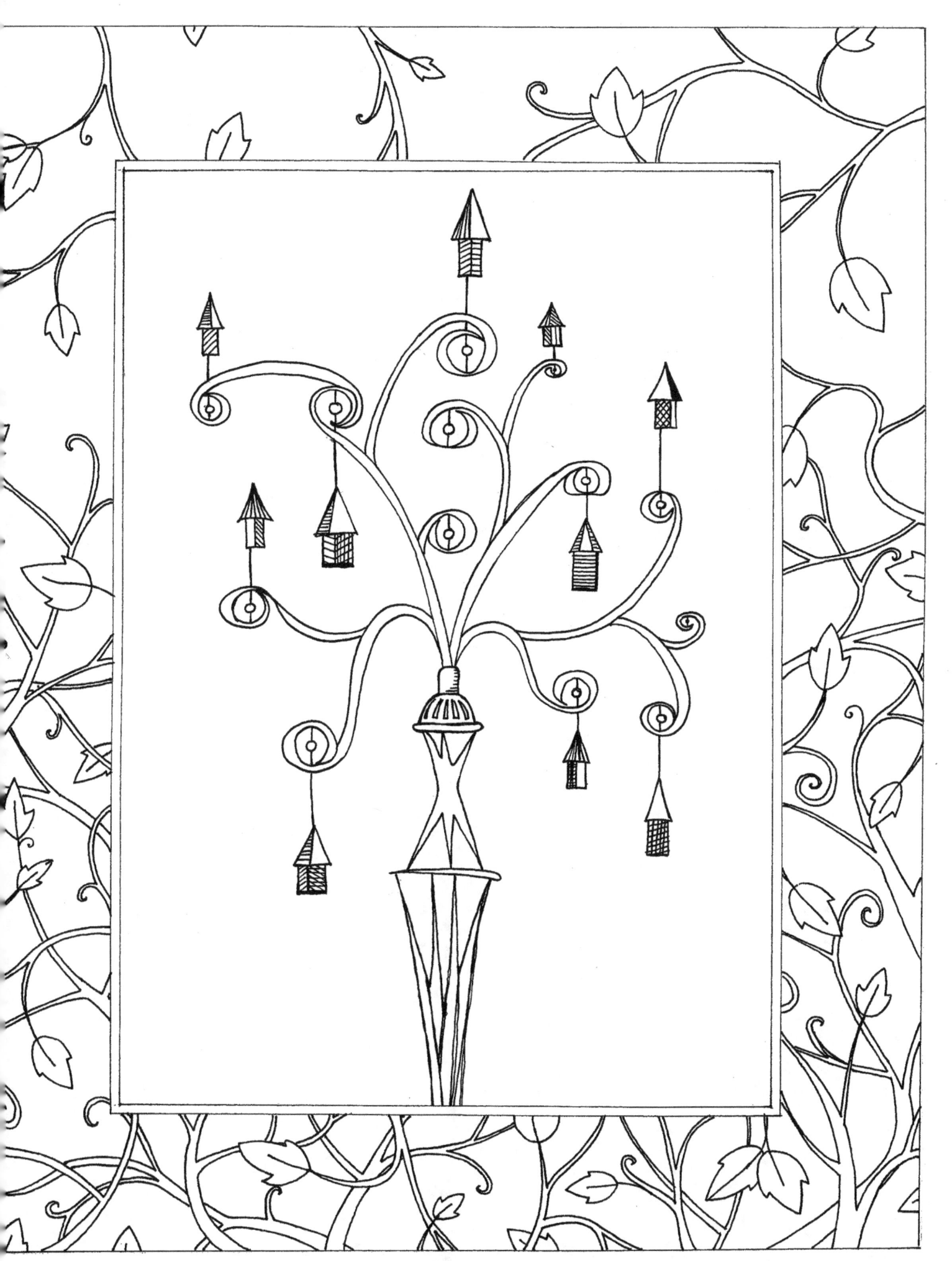

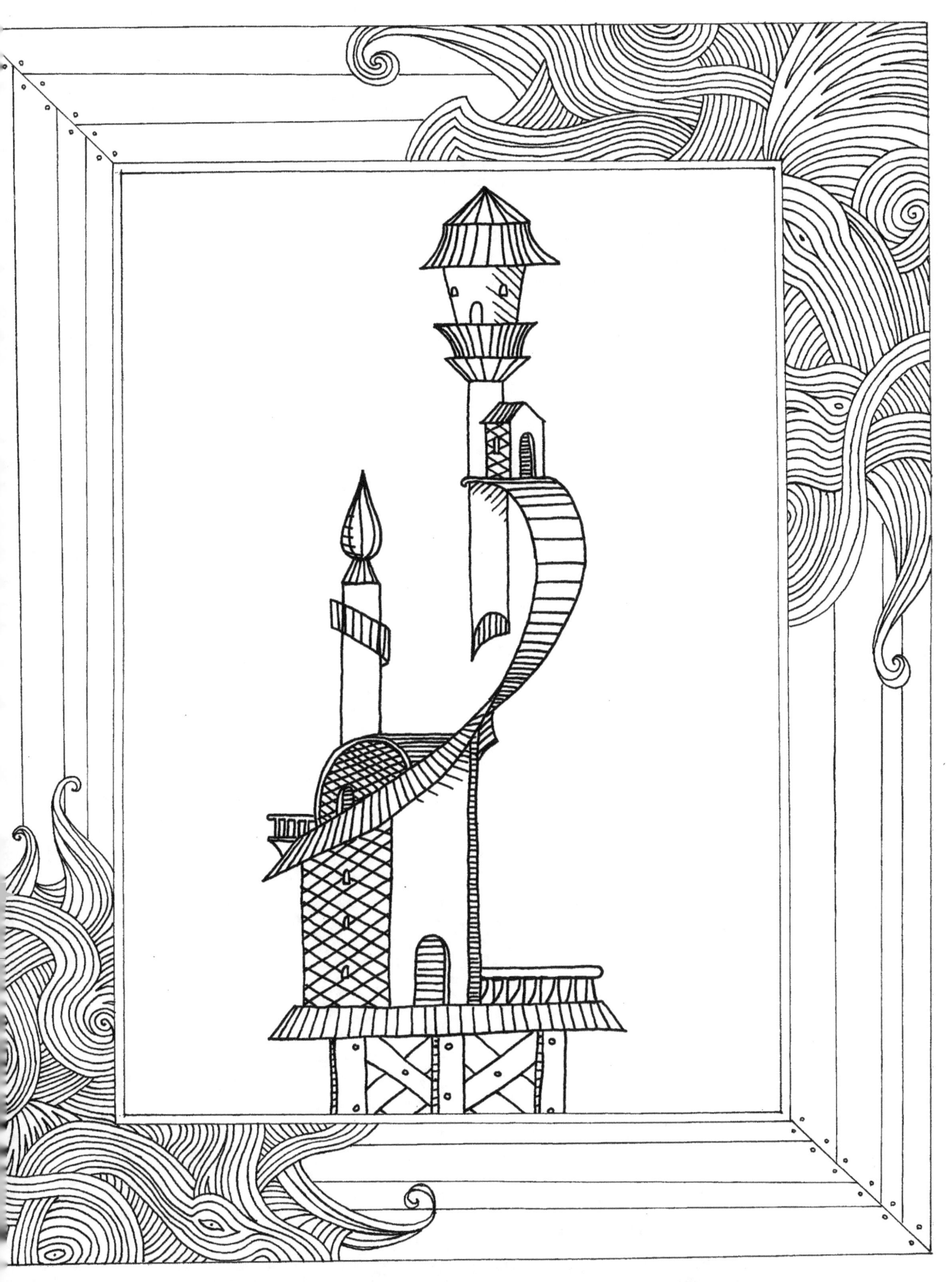

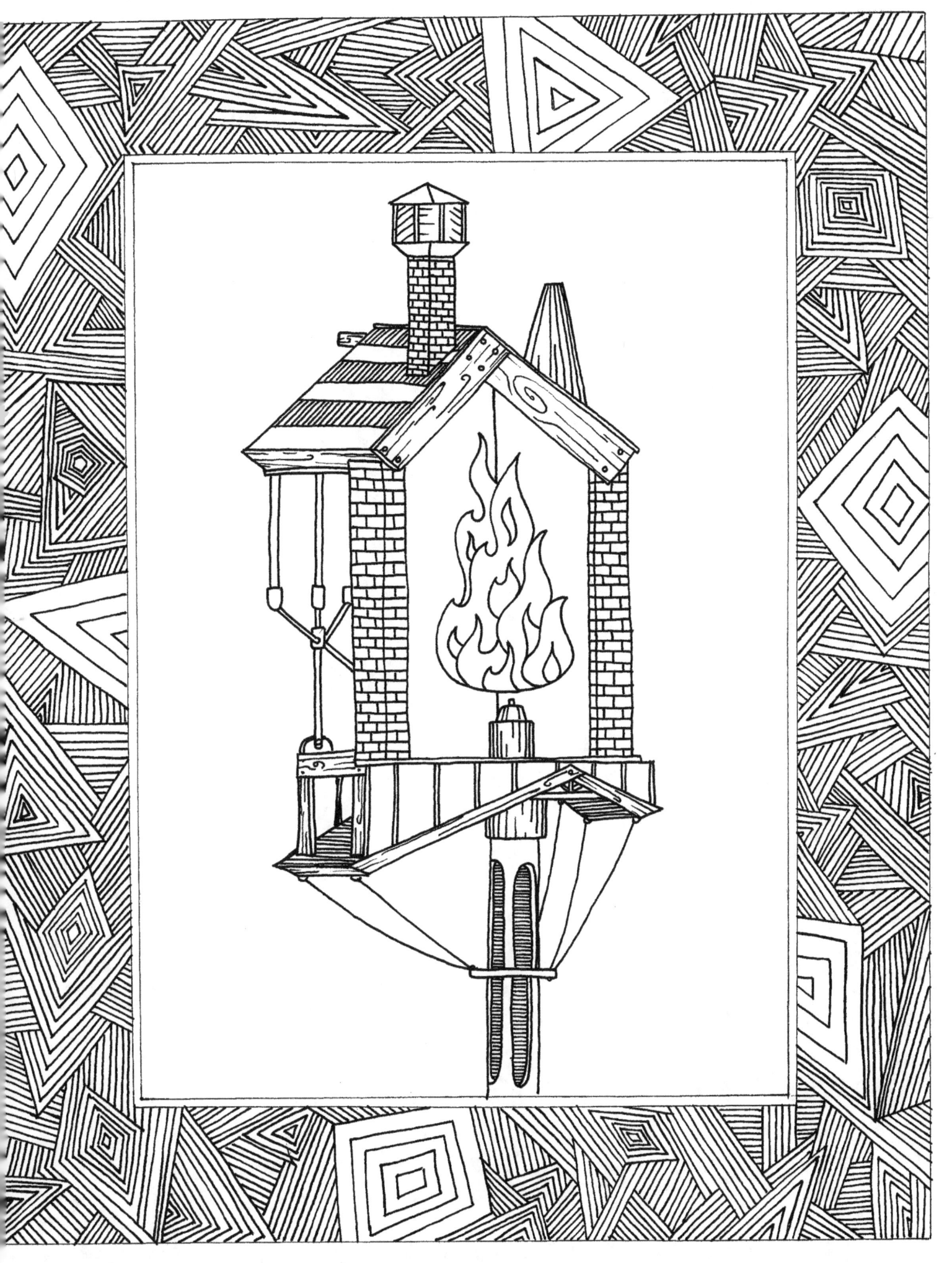

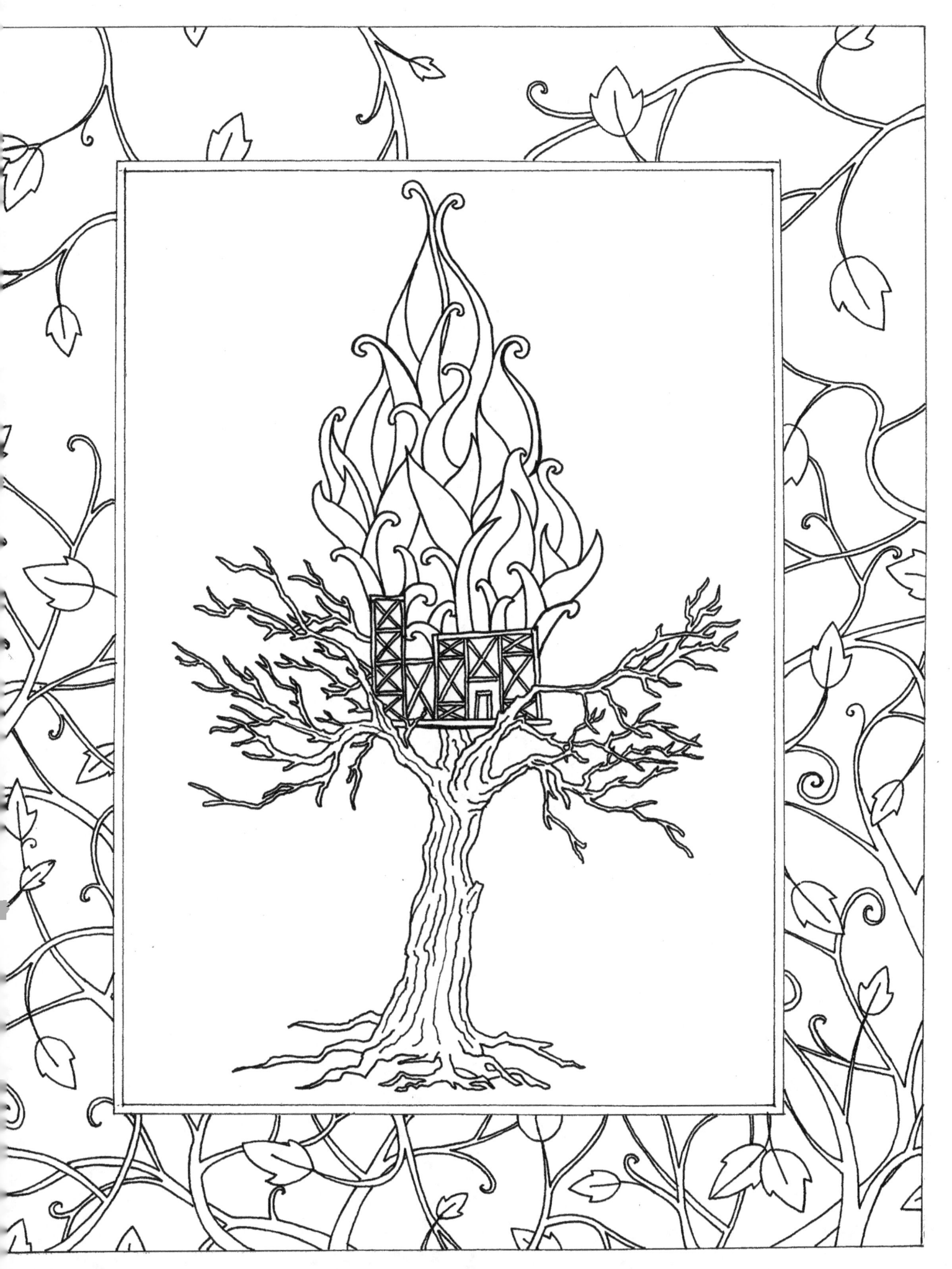

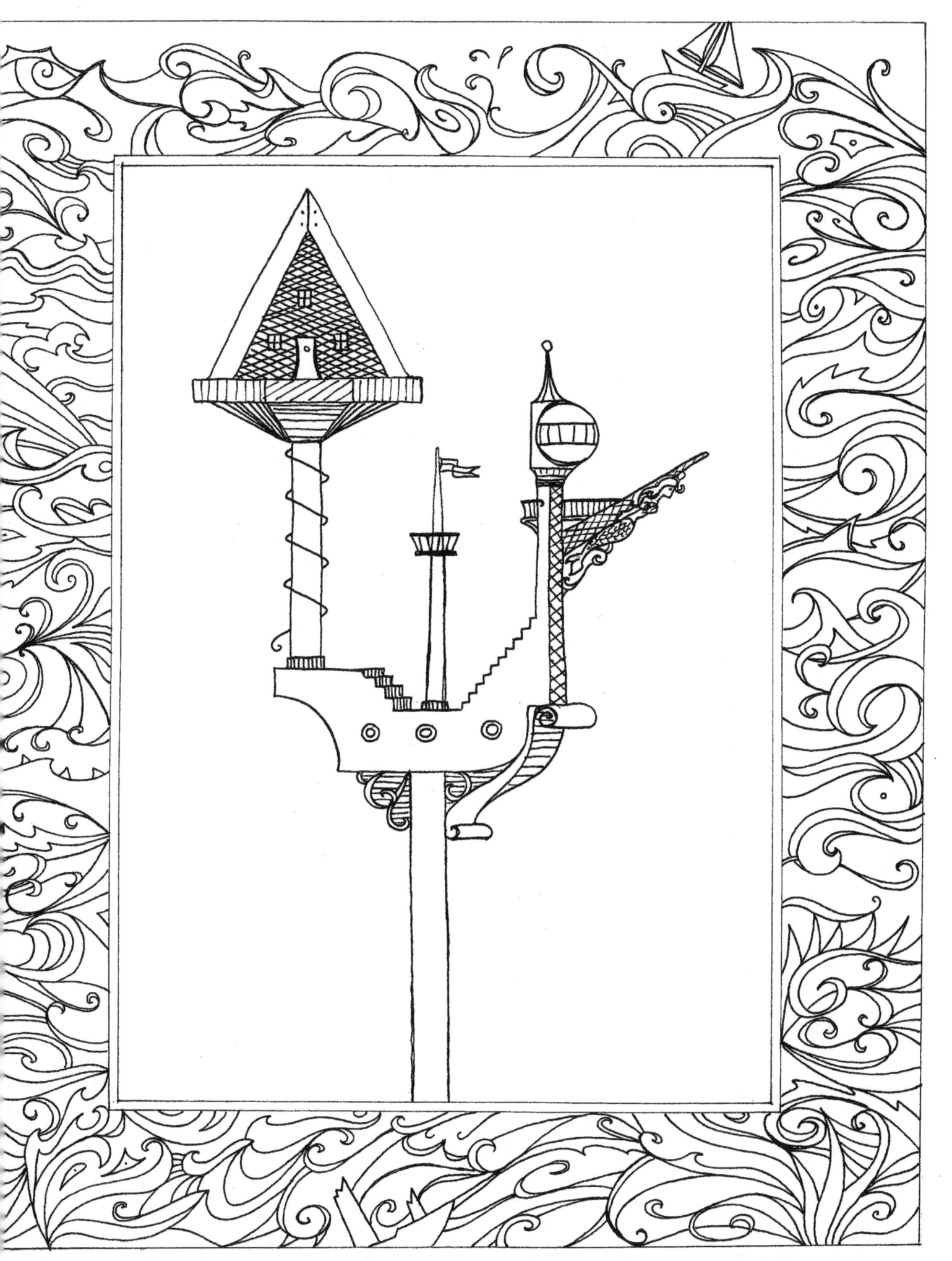

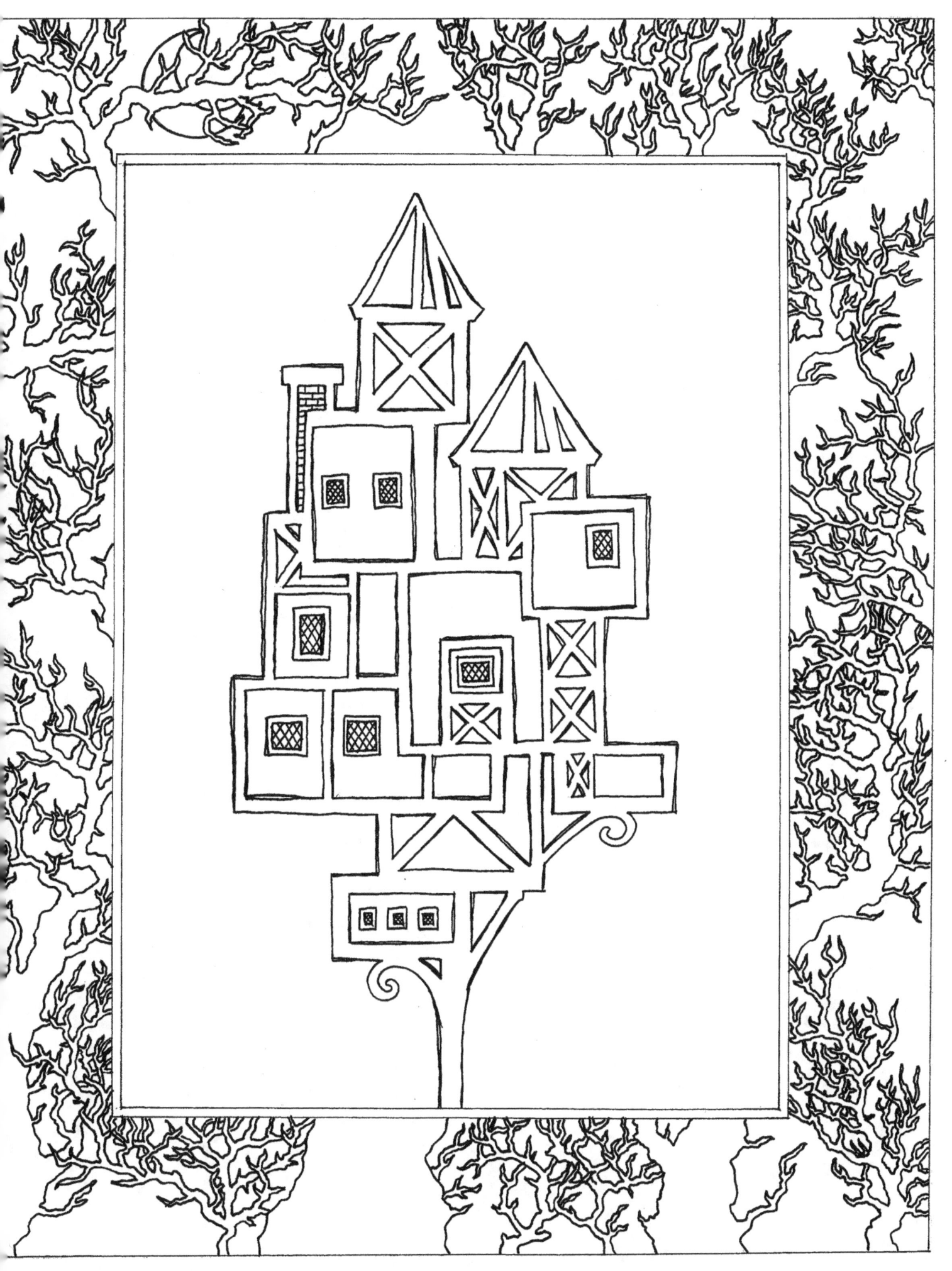

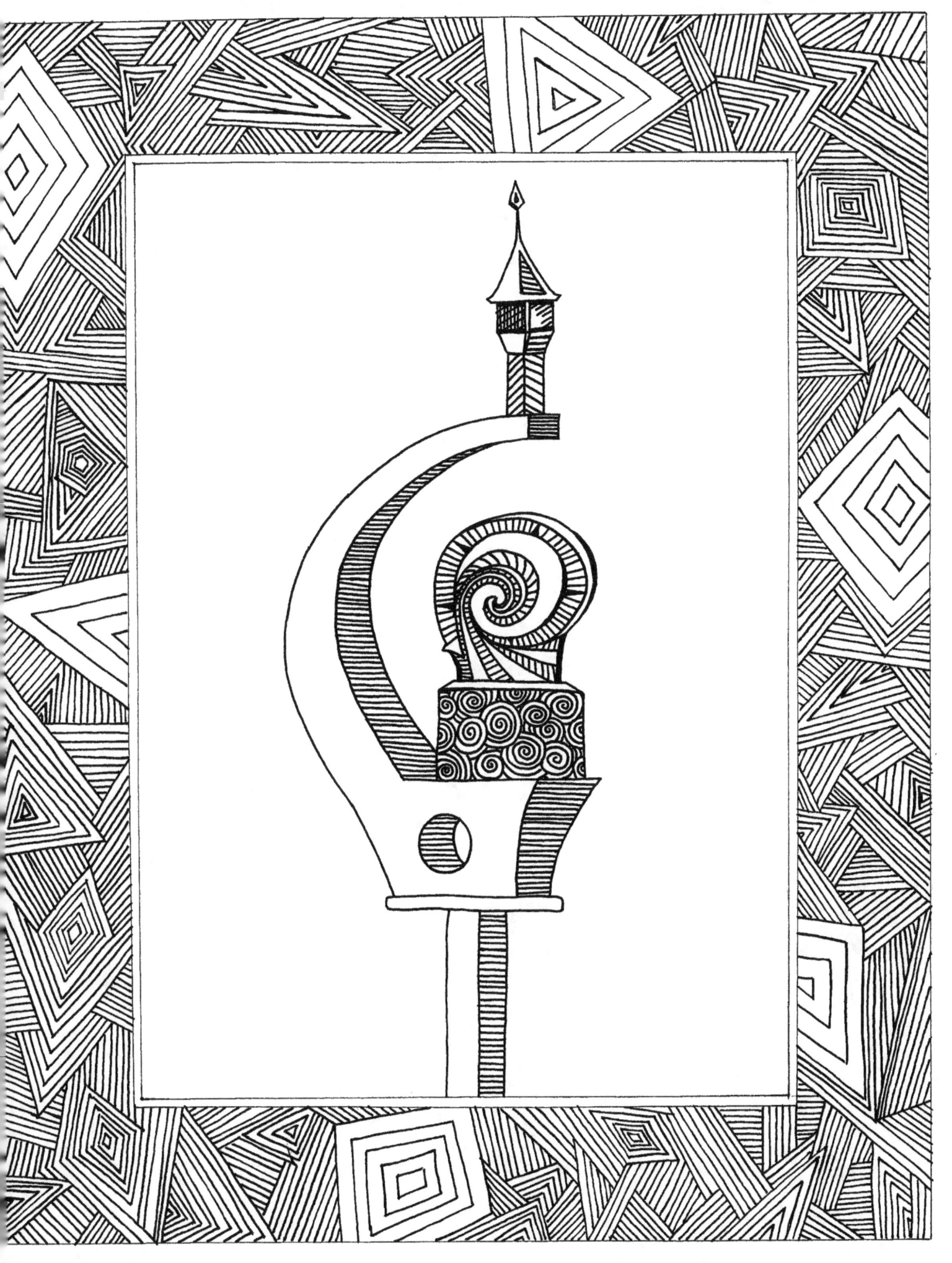

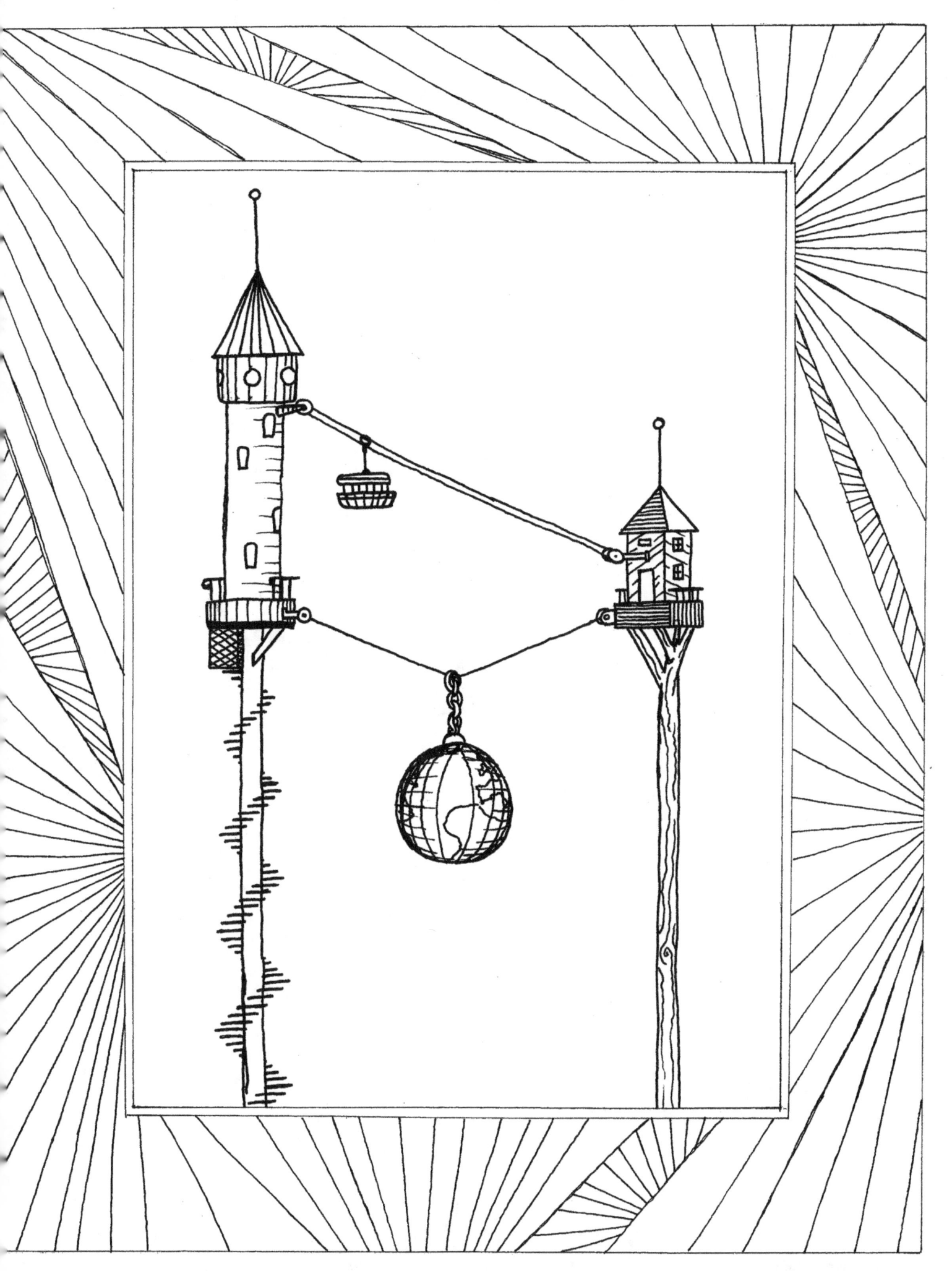

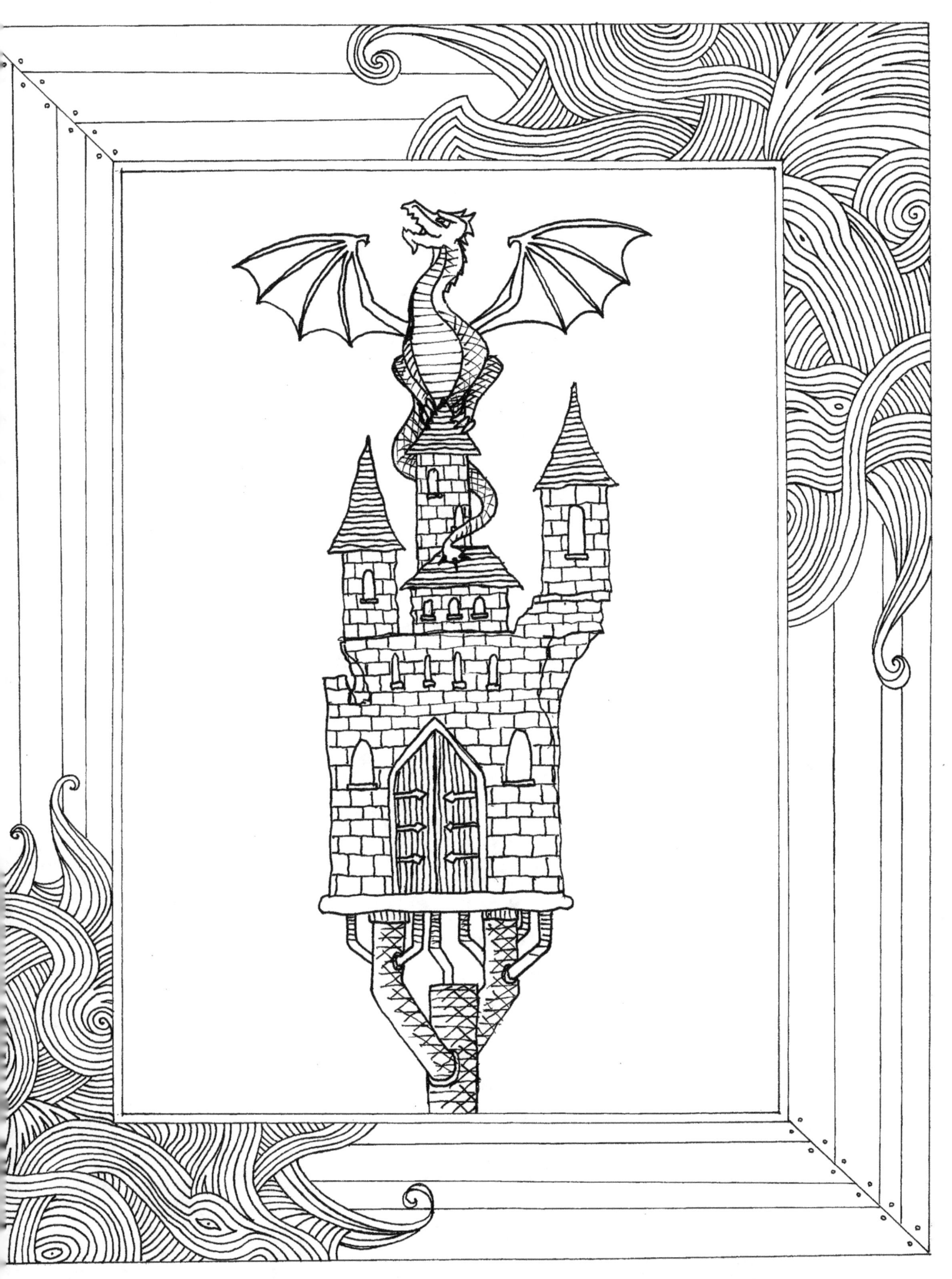

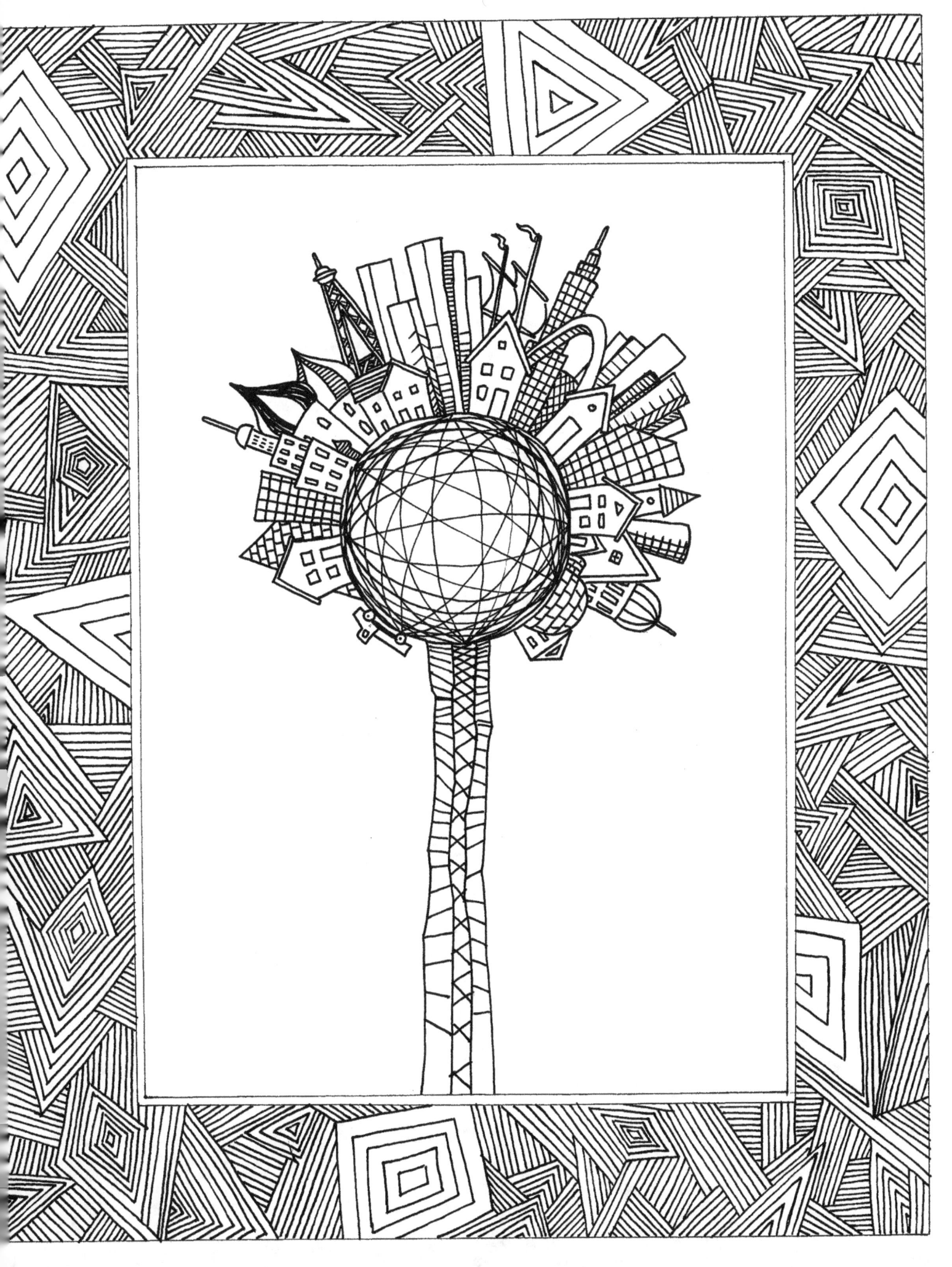

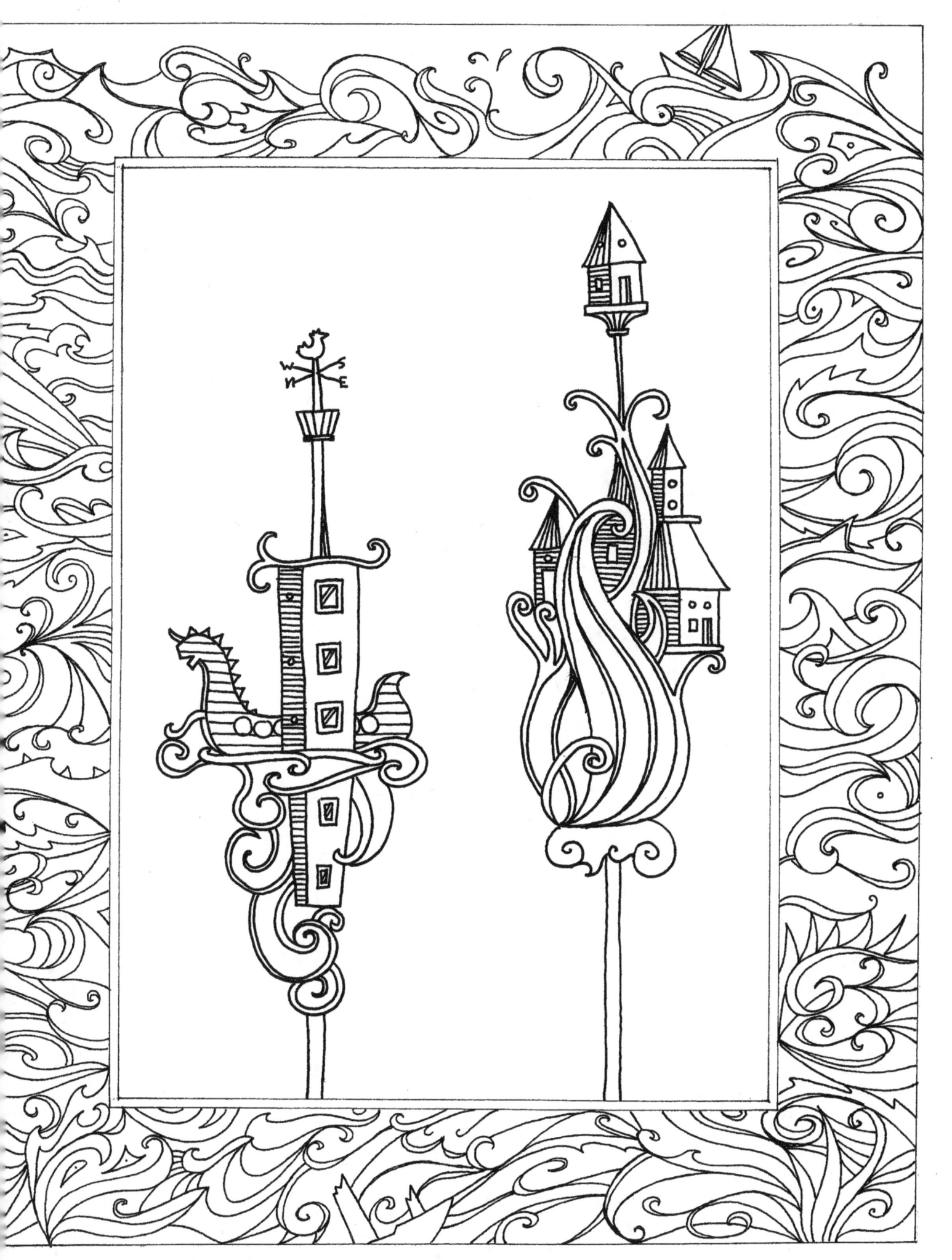

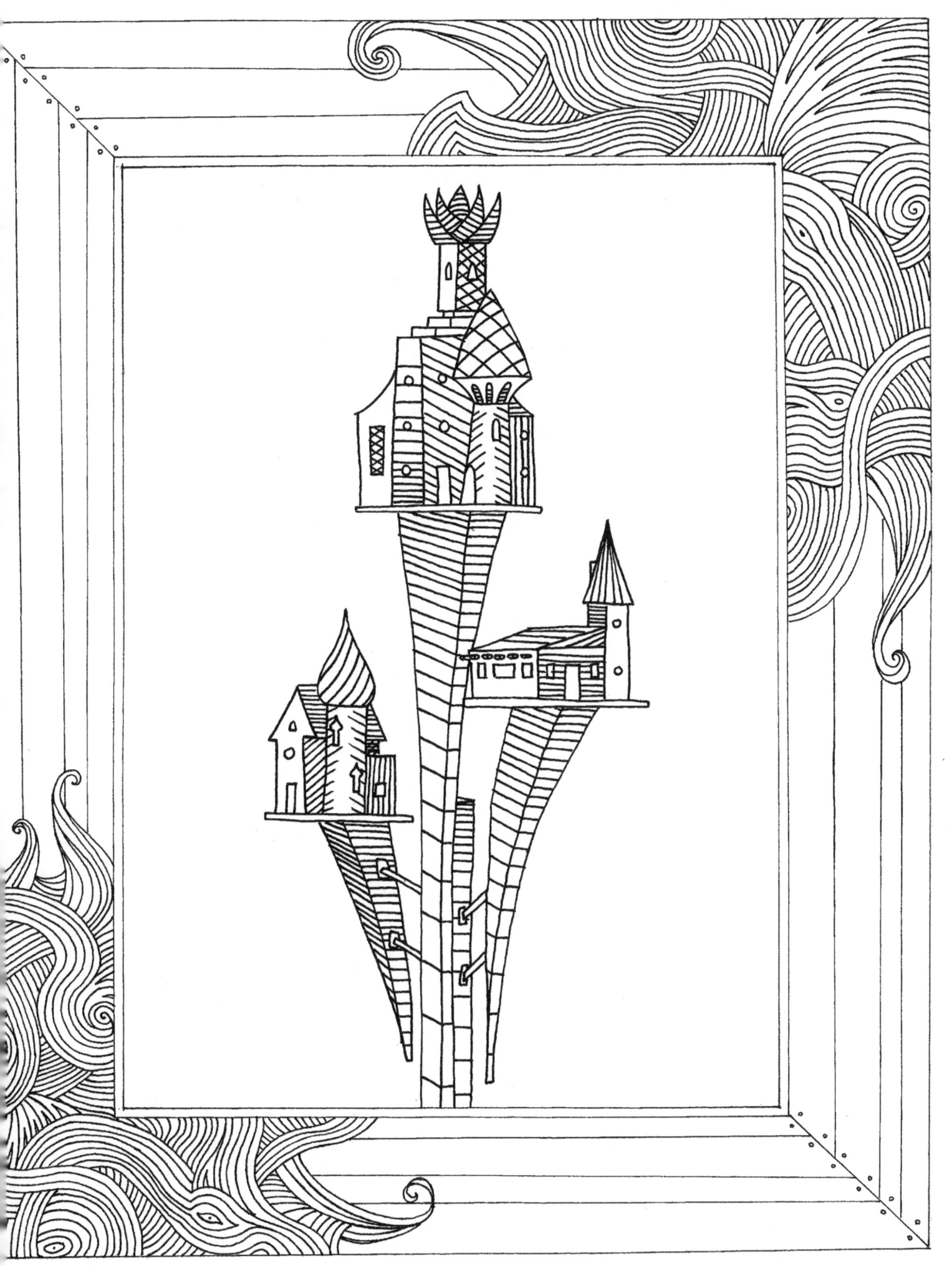

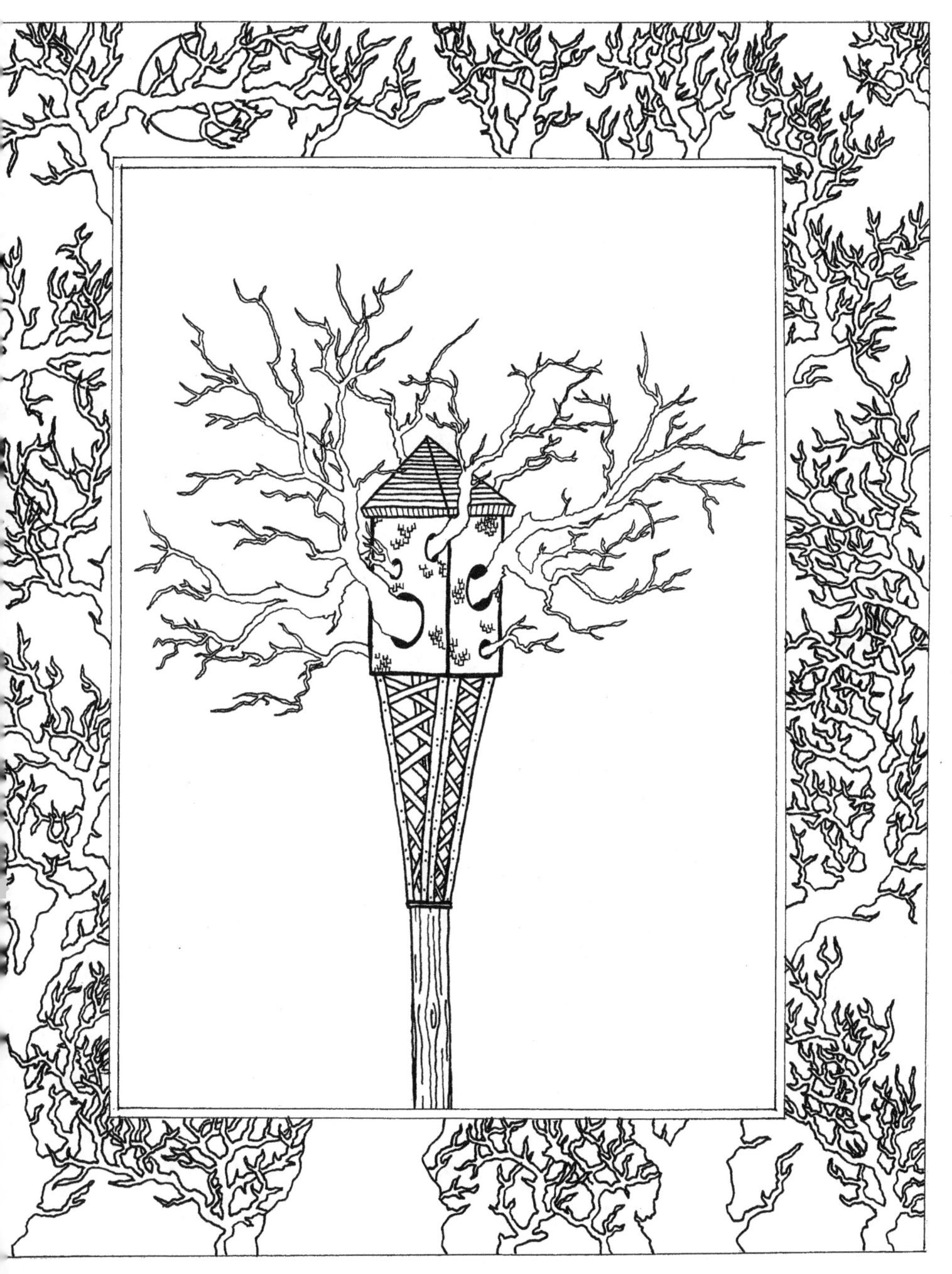

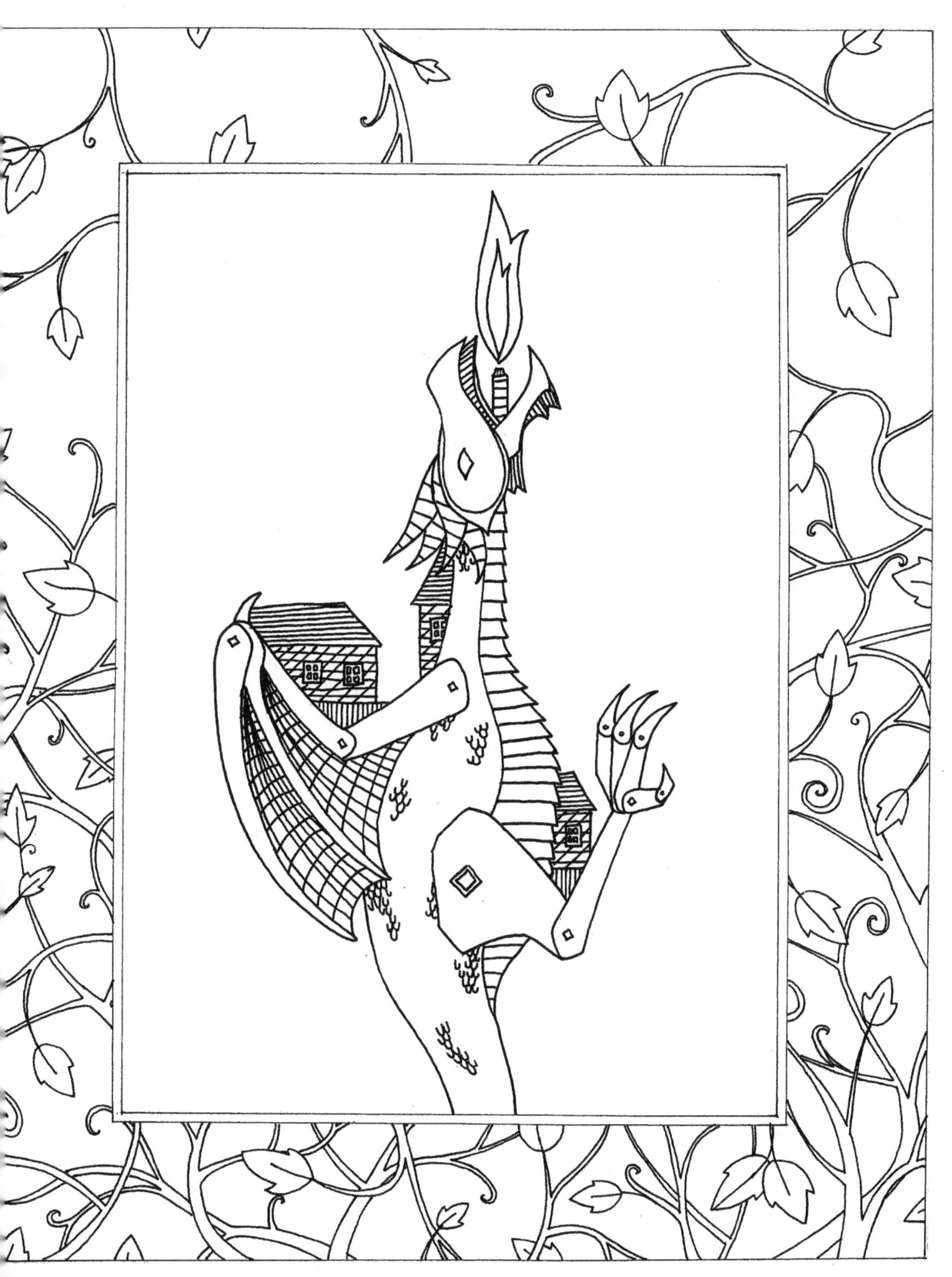

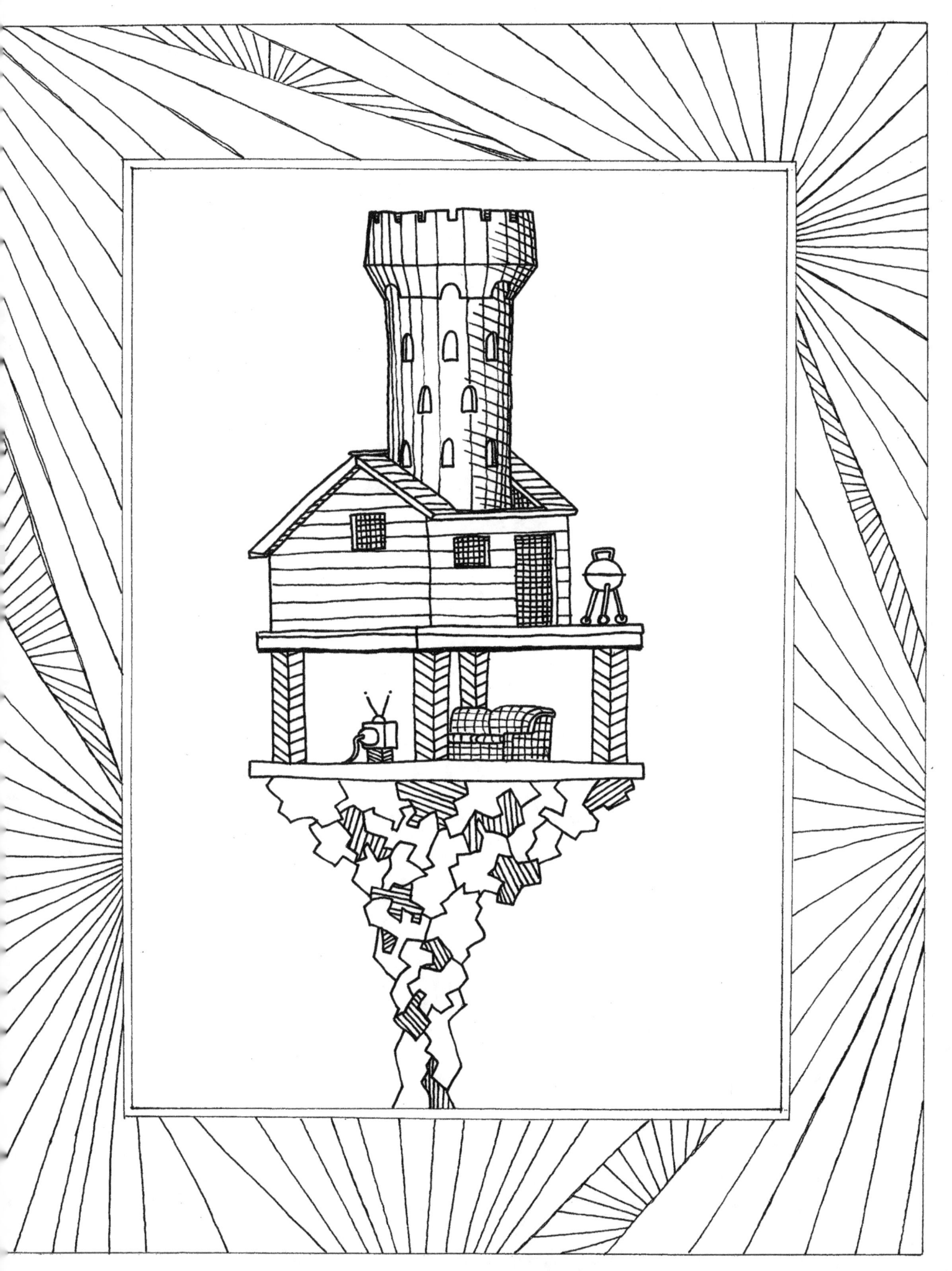

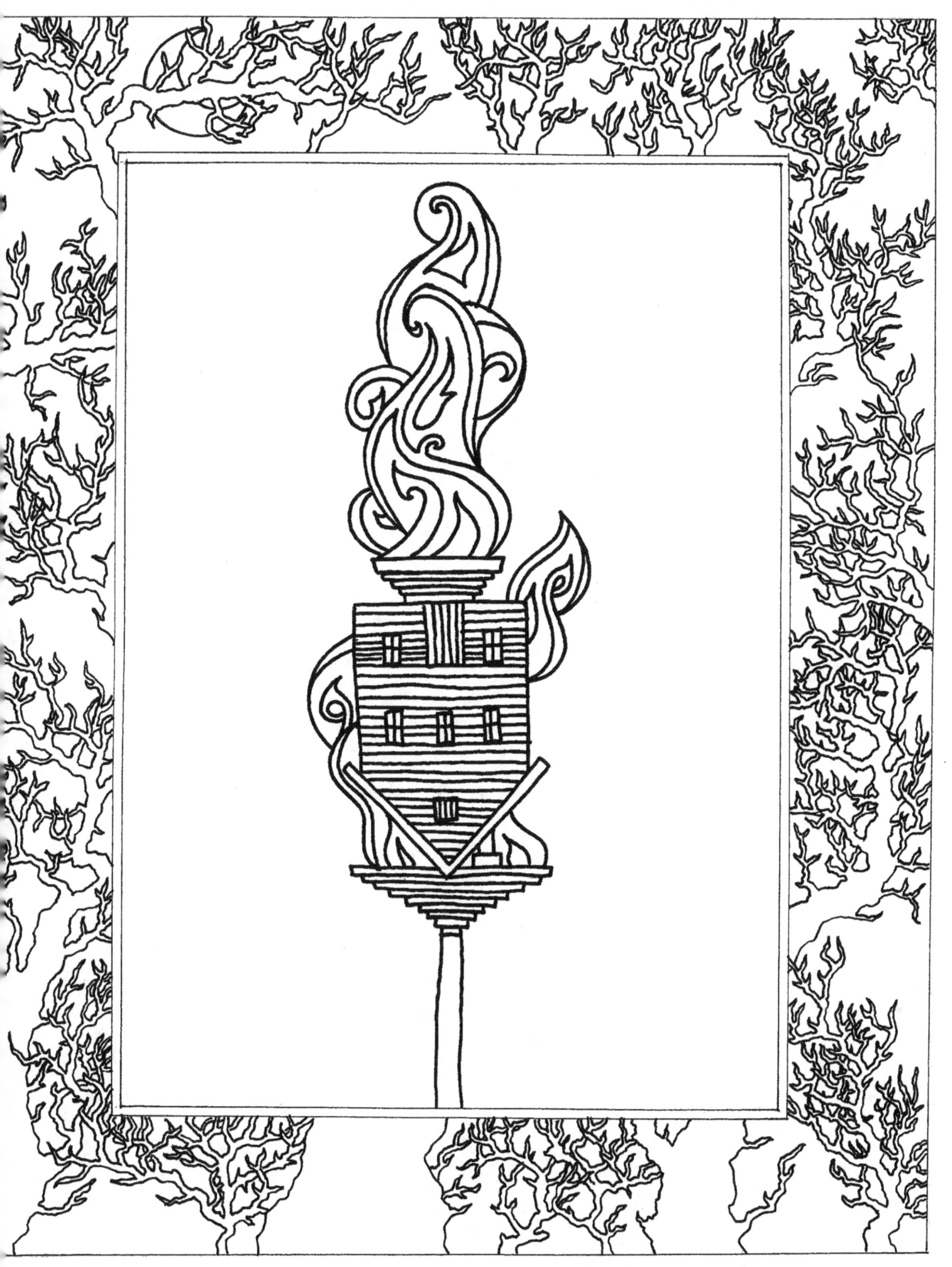

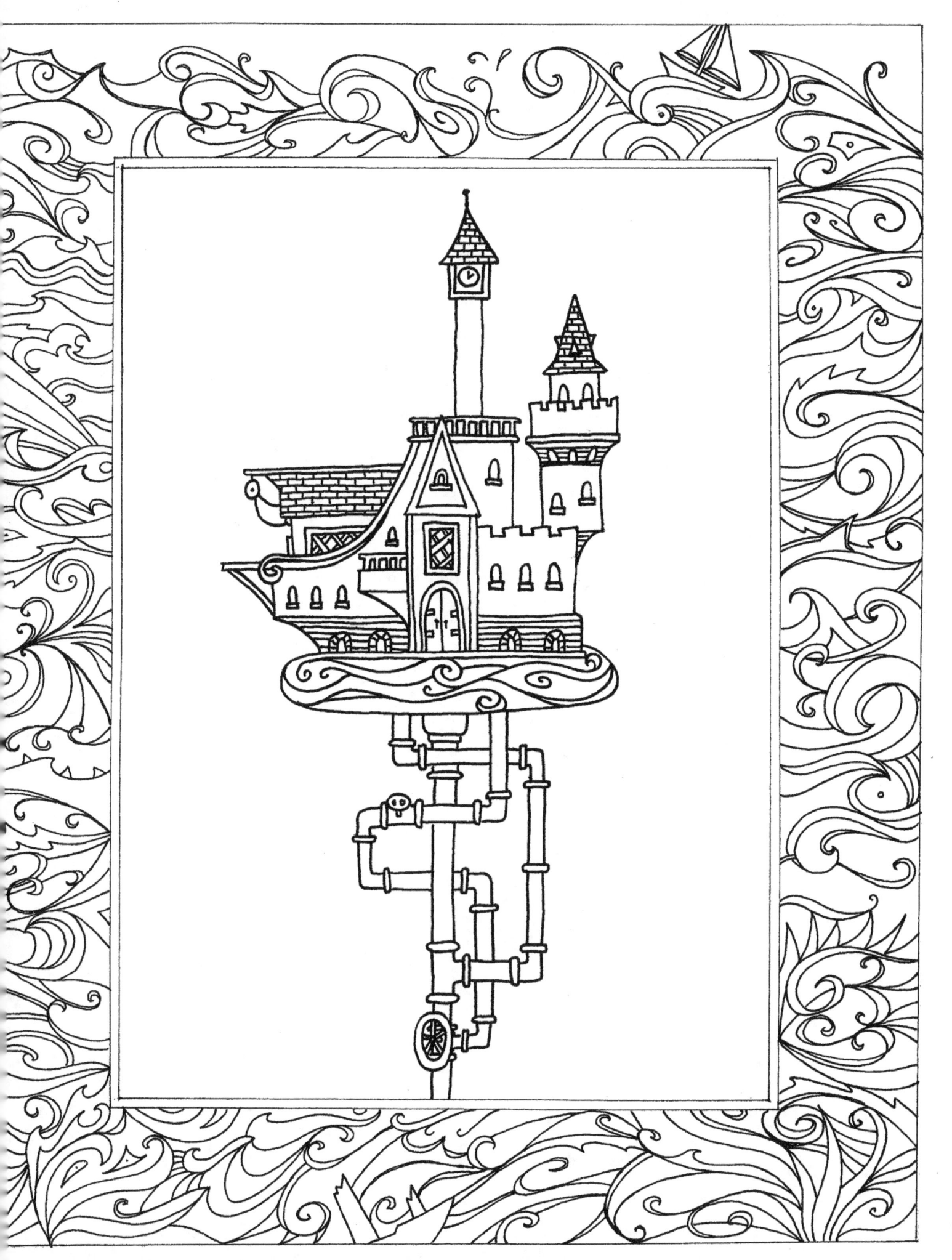

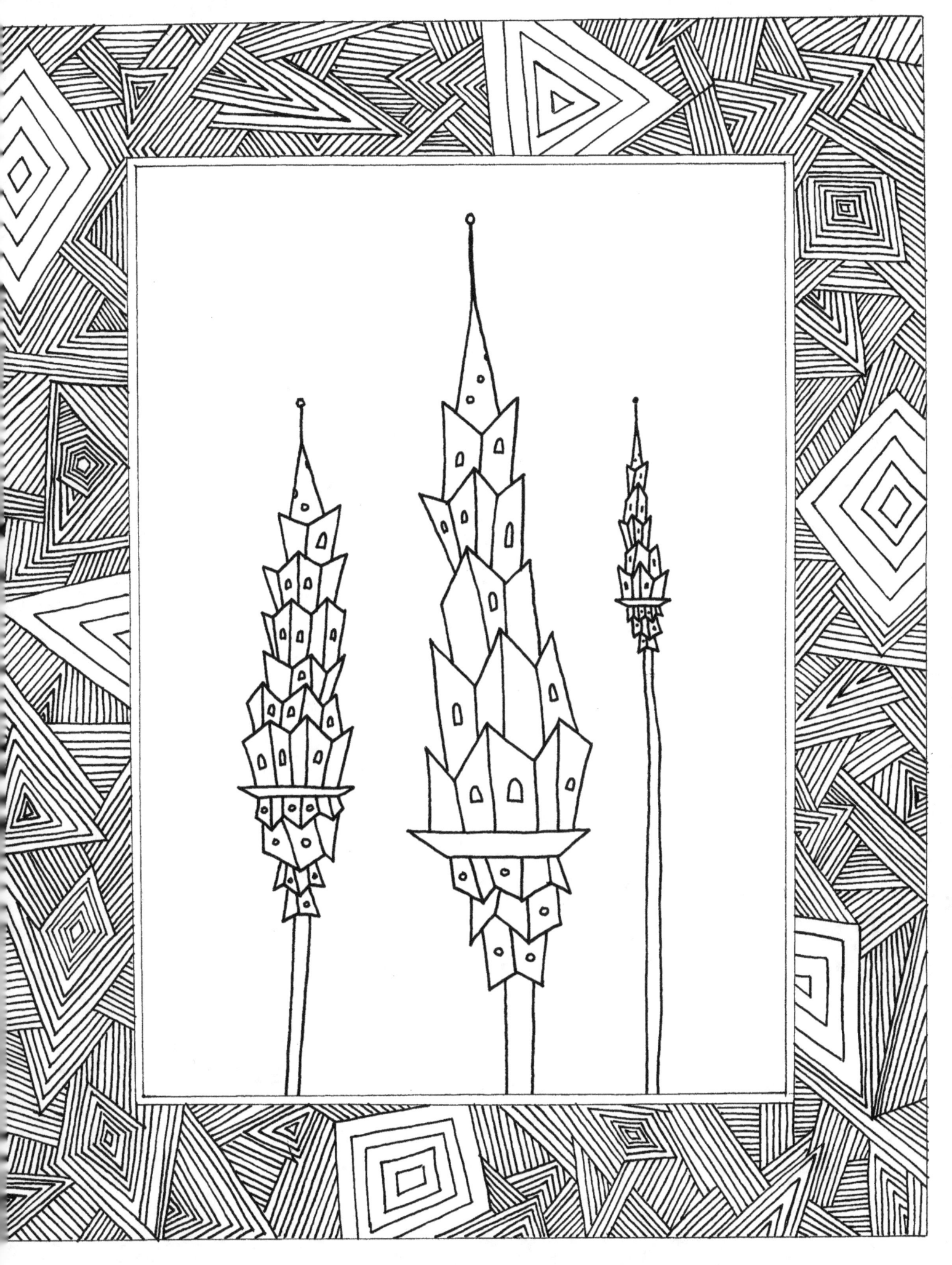

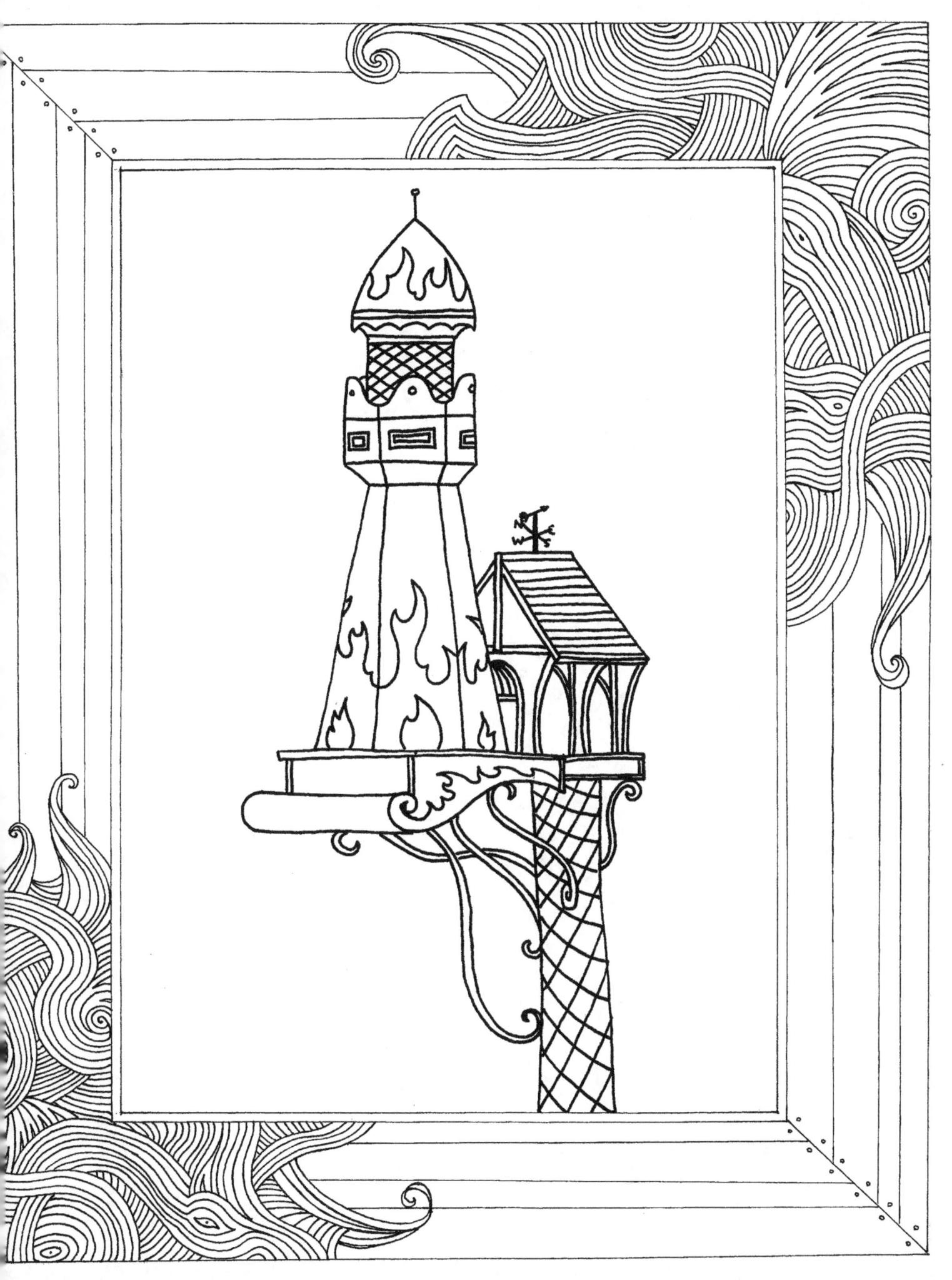

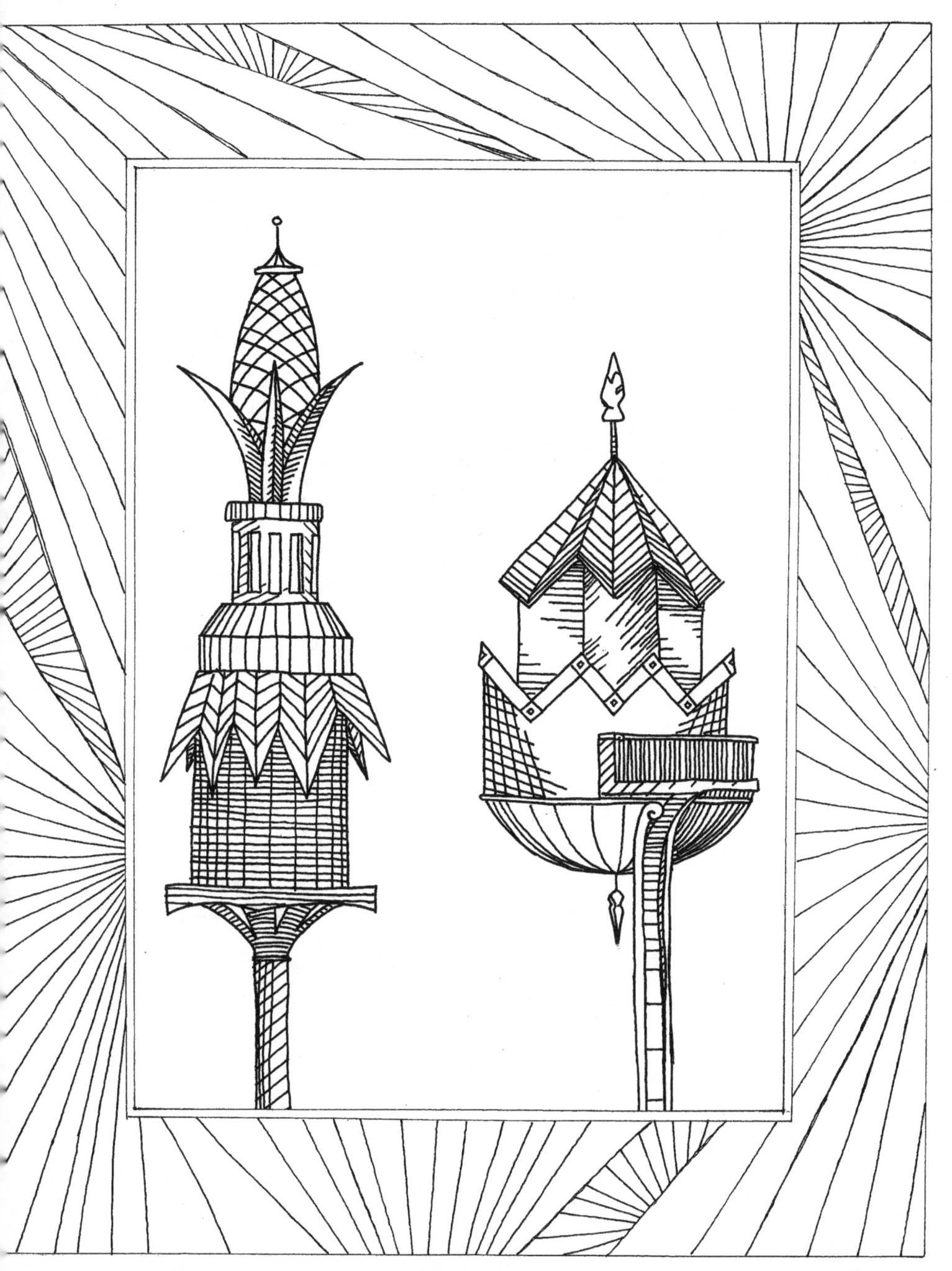

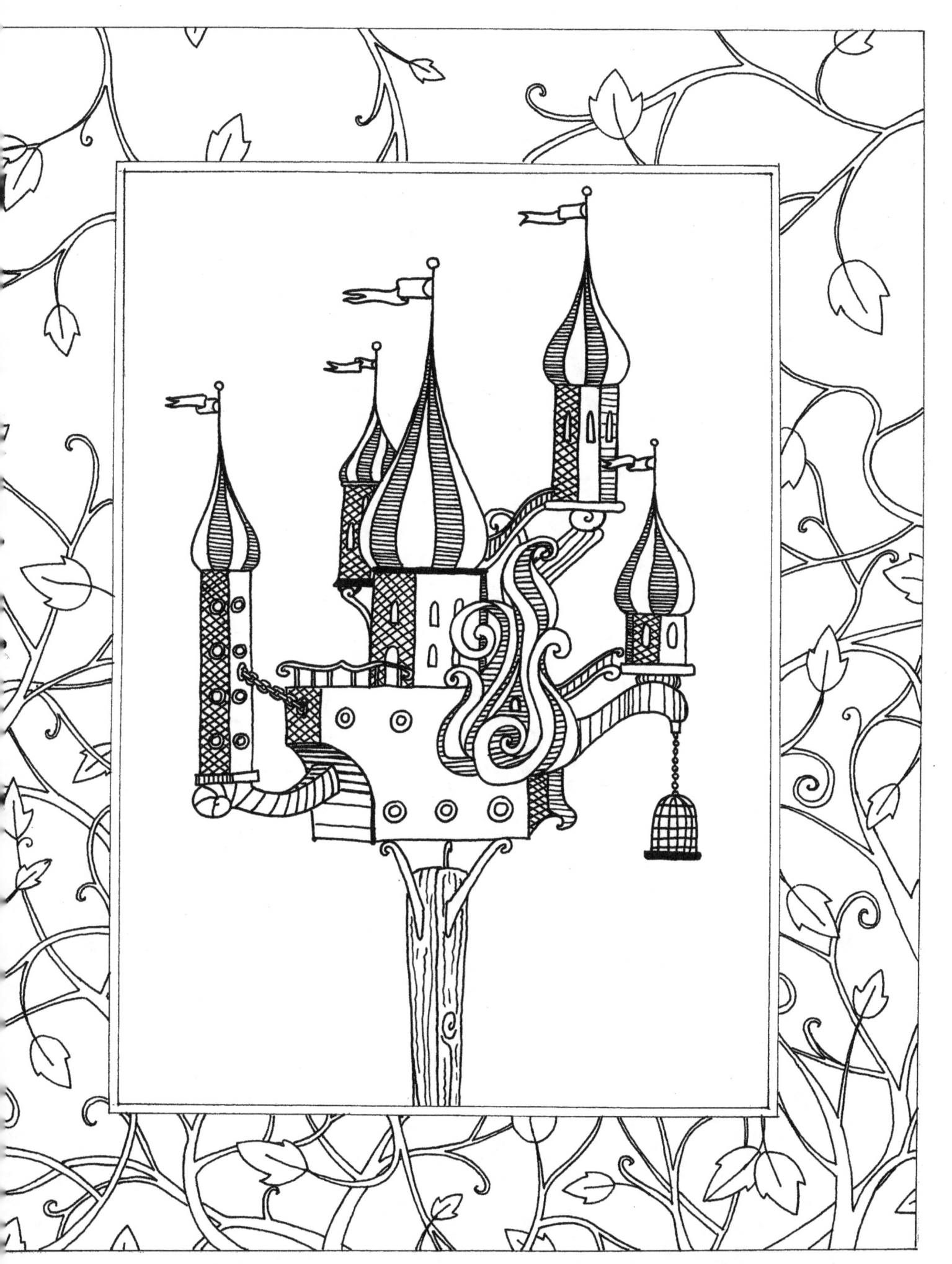

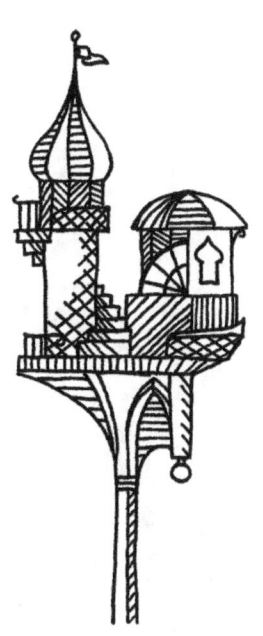

MICHAEL VINCENT BUSHY IS A PRINTMAKER, BOOKBINDER, AND ART TEACHER WHO LIVES AND WORKS IN PITTSFIELD, MASSACHUSETTS WITH HIS PARTNER REBECCA AND THEIR DOG FRANK. THEY NEED MORE DOGS, BECAUSE FRANK'S GETTING WEIRD.

THANK YOU TO ALL MY FRIENDS, CO-WORKERS AND STUDENTS WHO GLEEFULLY TESTED OUT THE DRAFTS, AND ESPECIALLY TO BECCA, FOR PRETTY MUCH EVERYTHING EXCEPT TESTING OUT THE COLORING PAGES.

www.ingramcontent.com/pod-product-compliance
Lightning Source LLC
Chambersburg PA
CBHW080831170526
45158CB00009B/2546